My Life
So far that is

James Willer PhD

Copyright © 2012 Author Name

All rights reserved.

ISBN:
ISBN-13:

DEDICATION

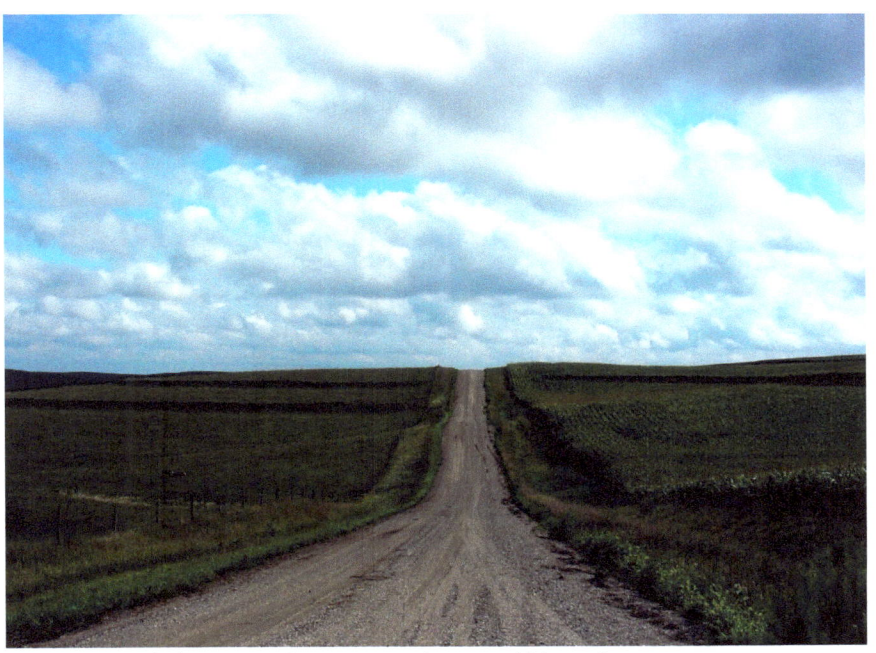

There is no place like home.

Contents

This book contains snaps shots of my life

It has been a life of unusual twists and turns

A path that has been unpredictable

Pictures speak a thousand words

And life continues to go round and round

ACKNOWLEDGMENTS

There is but one God and he is three,
I AM.

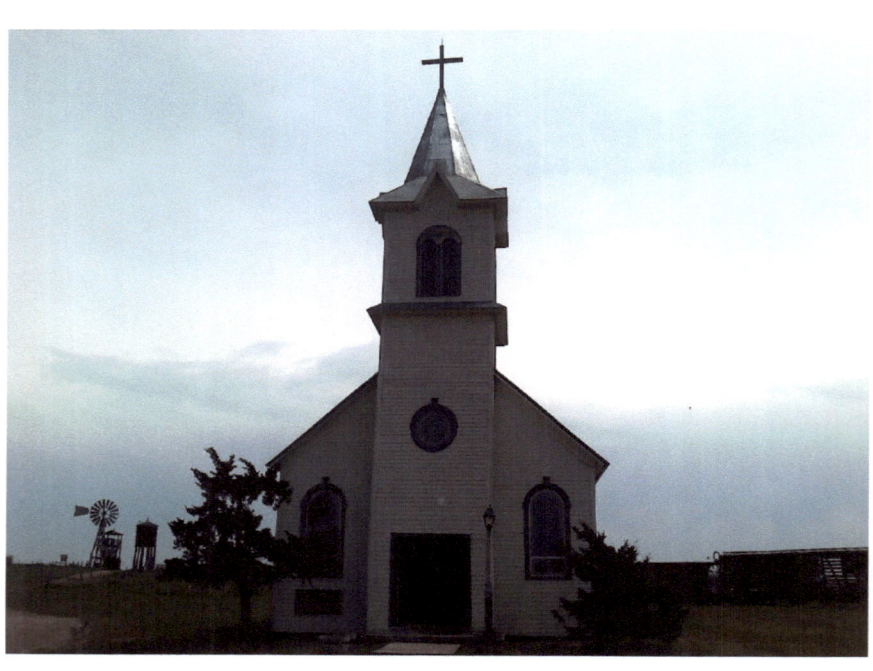

CHAPTER ONE: IN THE BEGINNING

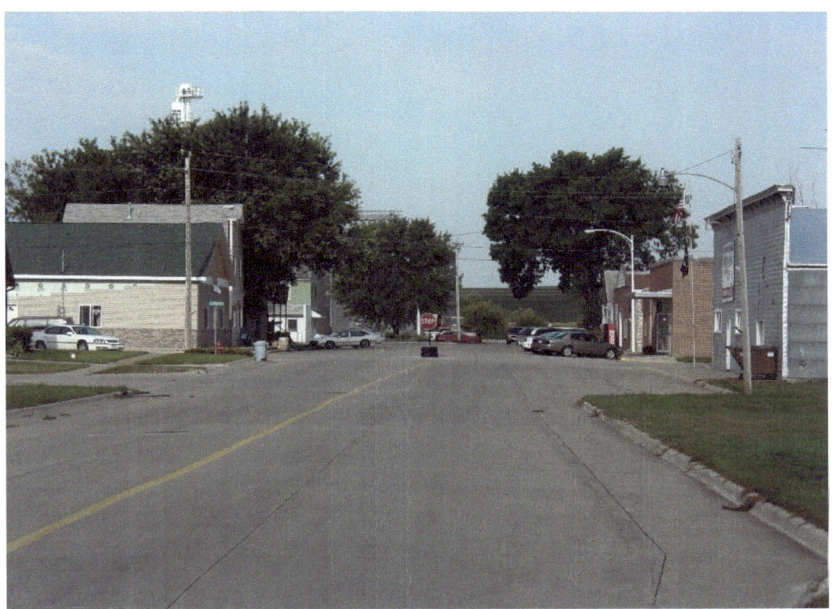

Brunsville, Iowa

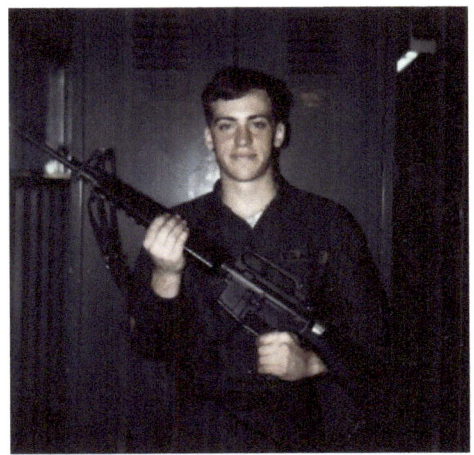

1974, Armed and ready to be sent to Vietnam

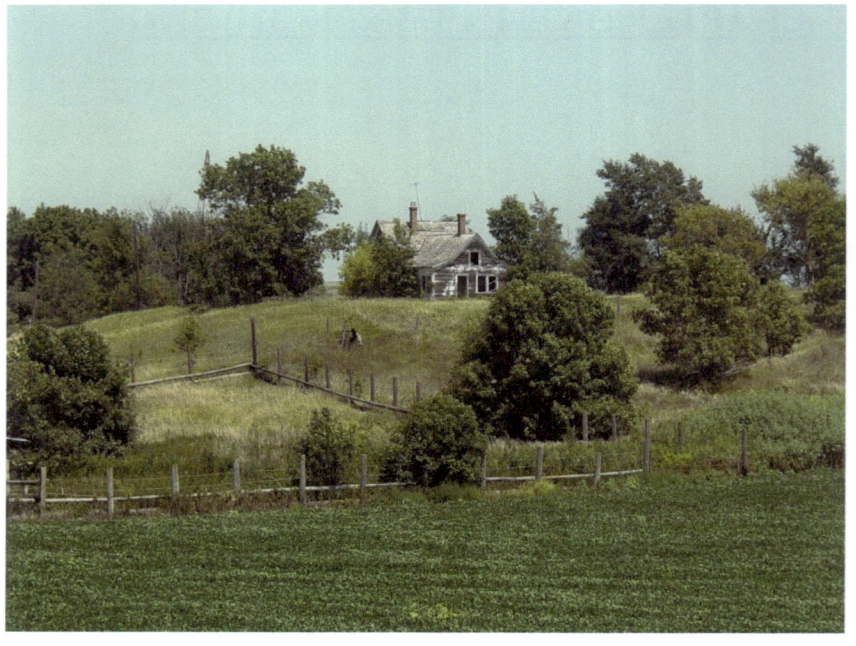

Old Hunting grounds, where the deer and squirrels play. Many old farm places held hours of fine grounds for skills I would later need.

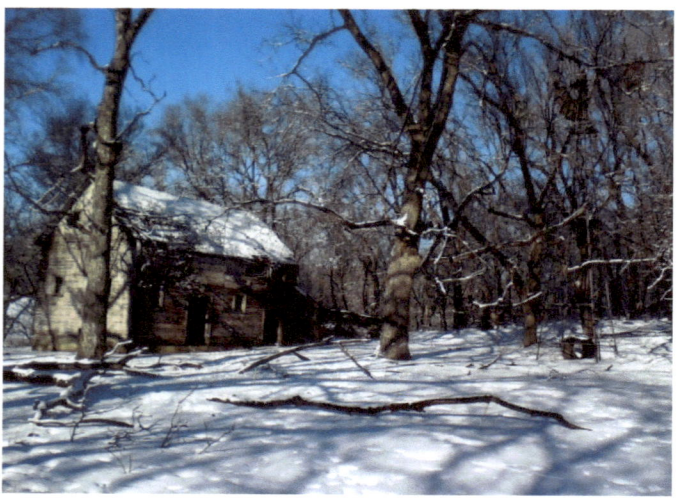

All pictures contained in this book were taken by me; except for those of me.

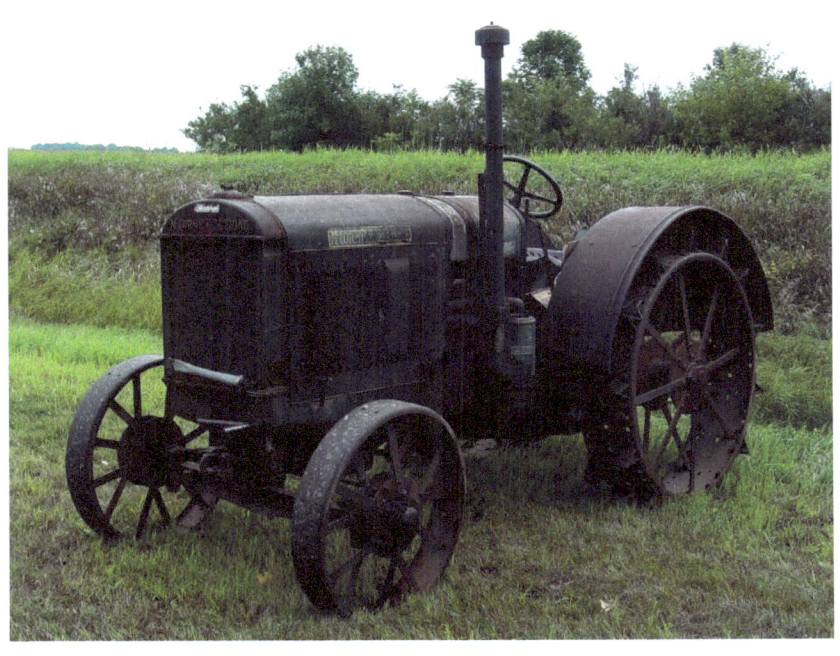

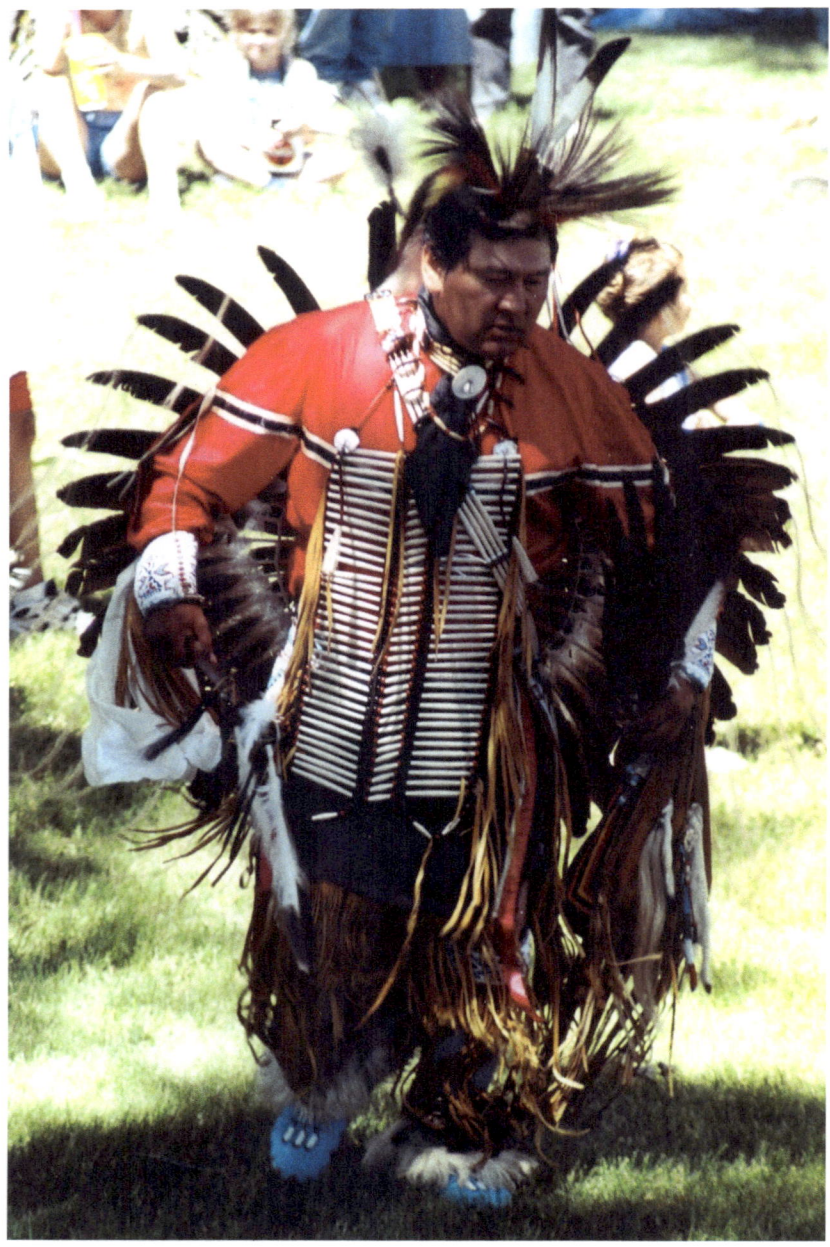

Sisseton, SouthDakota.

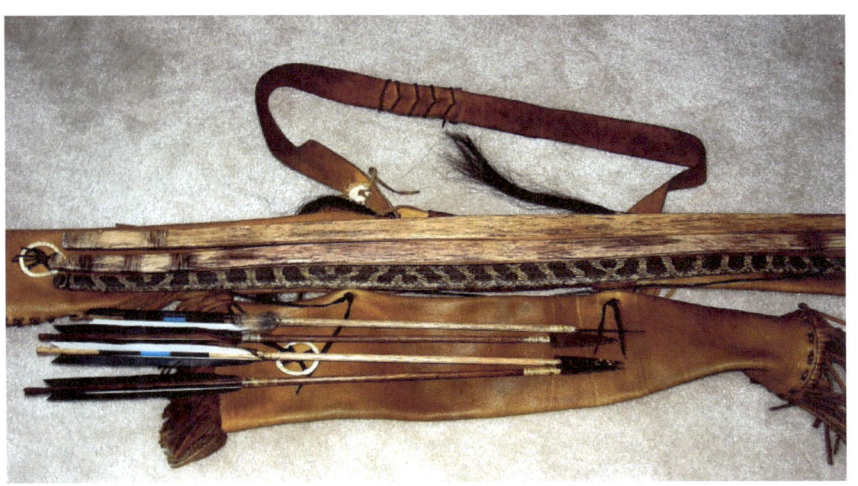

My craft projects, it has been mental therapy.

West of Brunsville

My father liked things that were old….like him. So in our travels…….

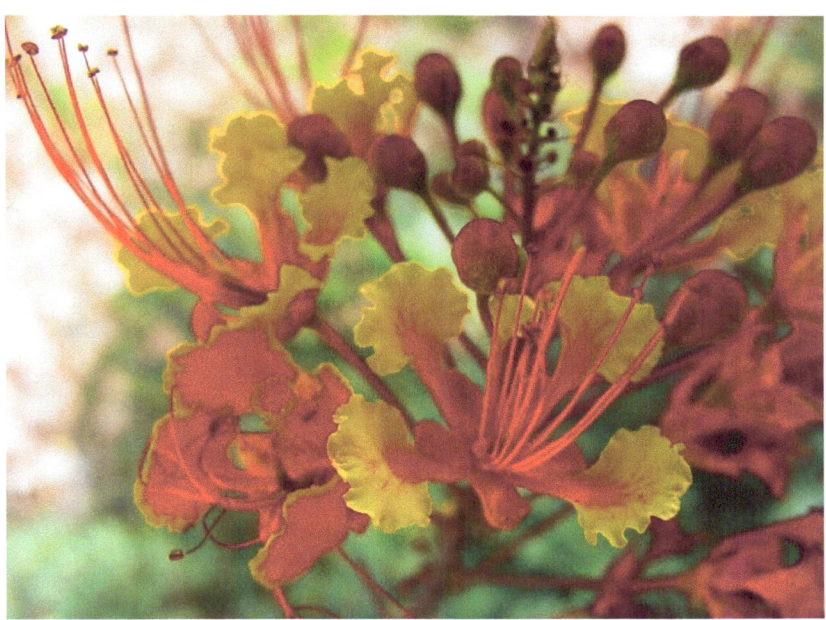

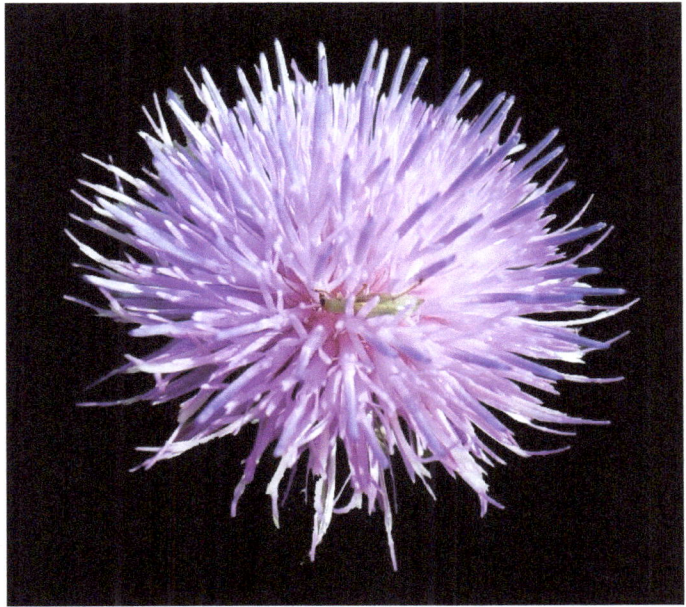

On the eighth day, God made flowers. I liked taking pictures of bright colors. I have taken hundreds over the years.

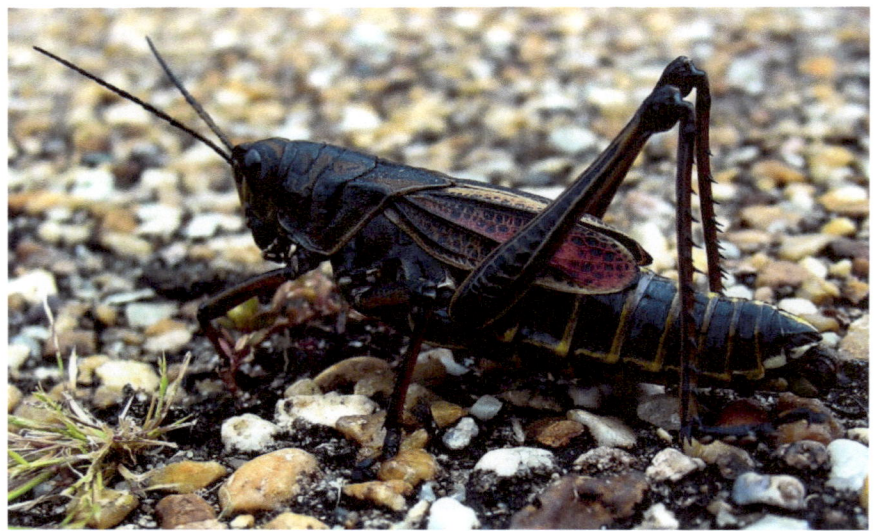

Georgetown, South Carolina

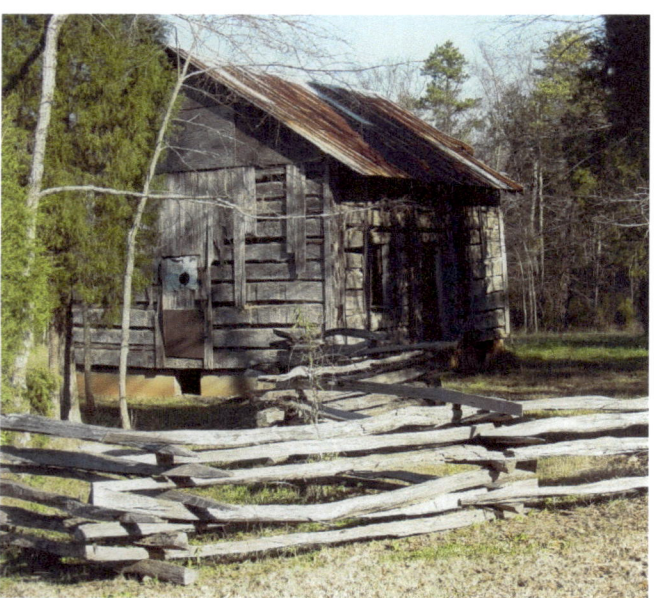

Old building seem to tell a story of times long past. A story for the imagination.

Military Deployments, of which there were many.

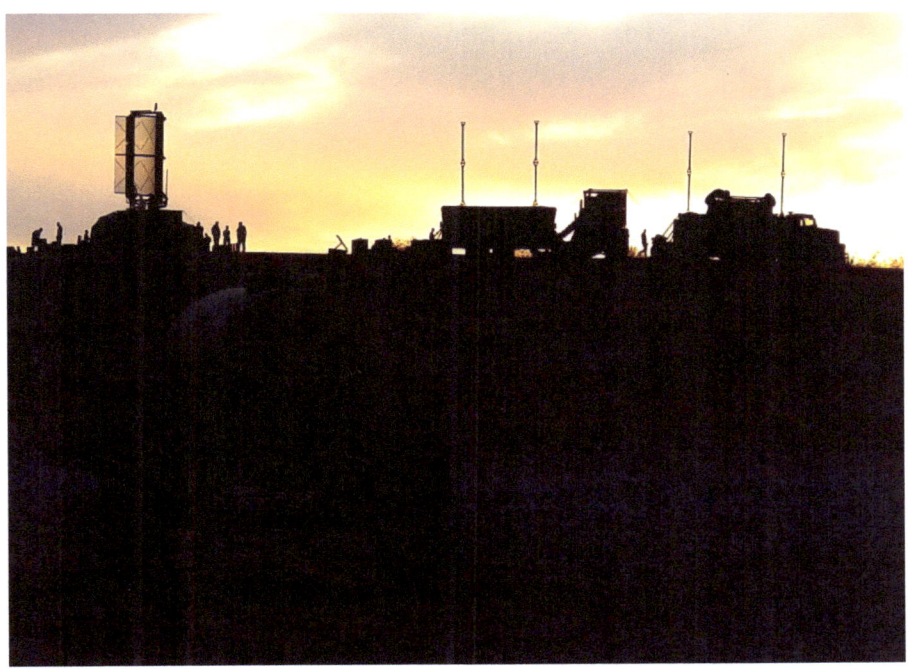

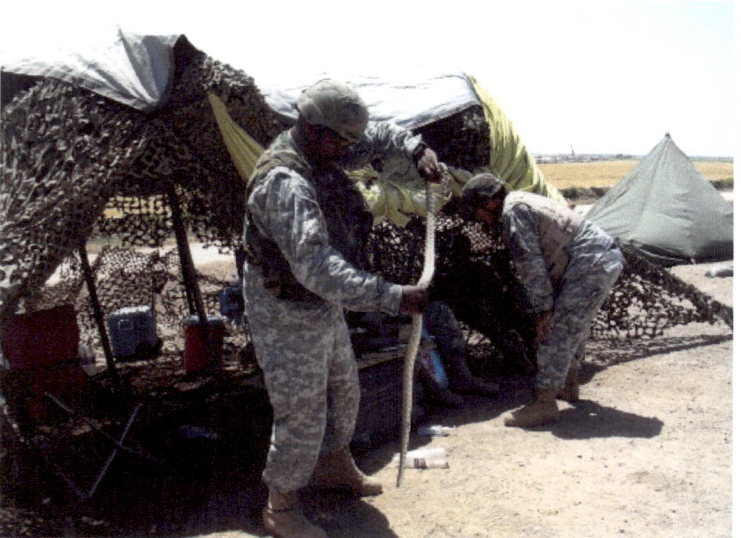

Playing with a snake of the n[on] poisonous typ[e]

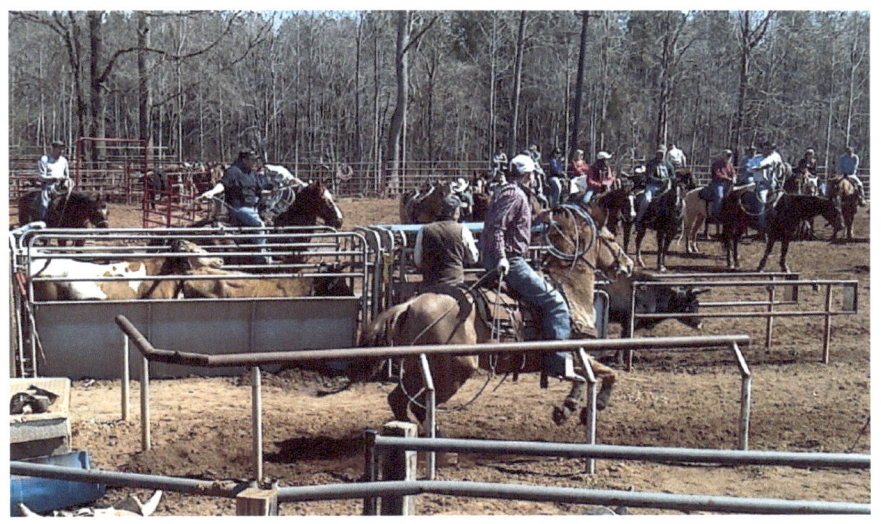

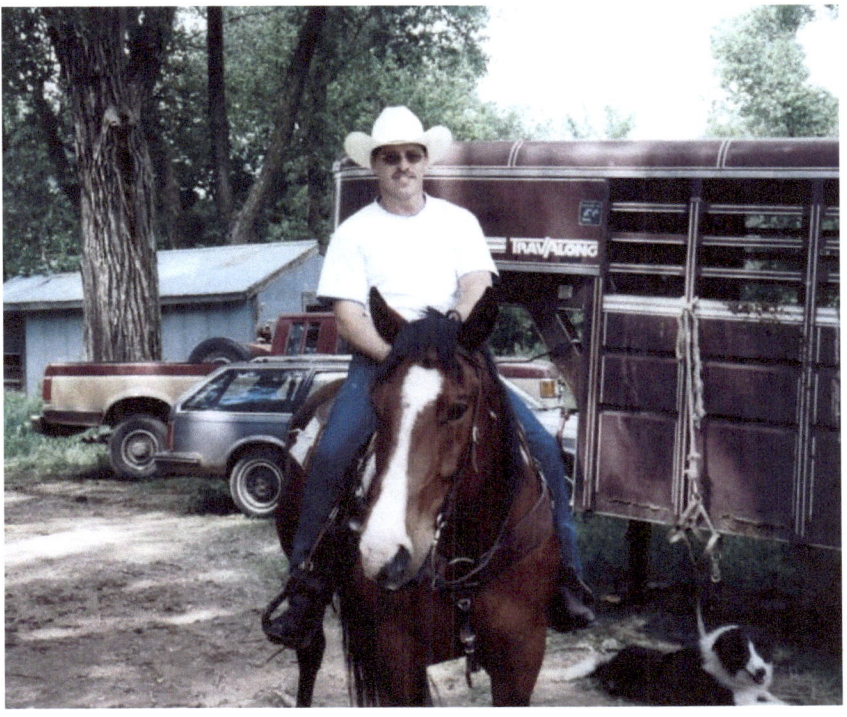

An old Iowa Farmer

The one I married

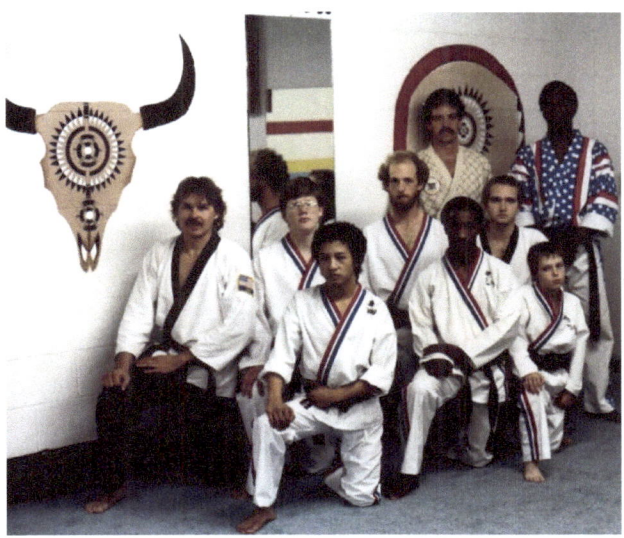

American Indian Center, Sioux City, Iowa

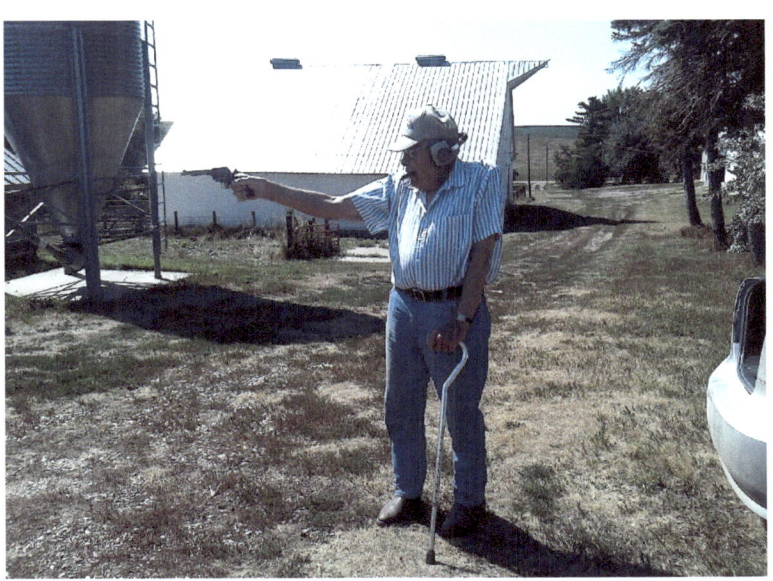

Father Alvin

Shooting on the farm the way shooting was meant to be.

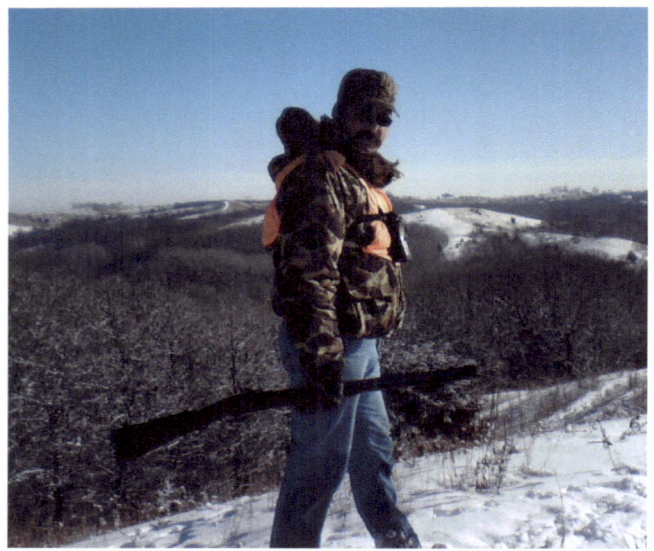

Brother John

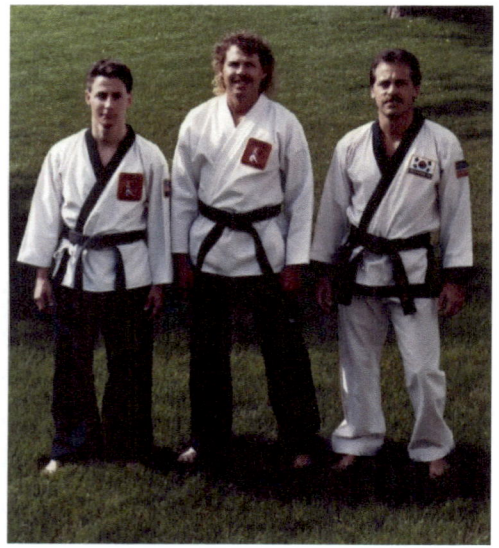

Black Belts: Kirkland G. DeWitt and Jeff Munderloh

Two of my teachers

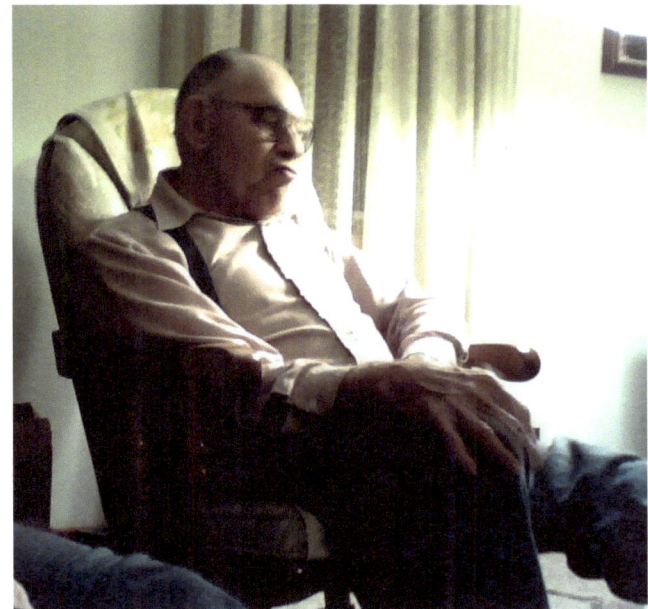

J. Alvin Willer

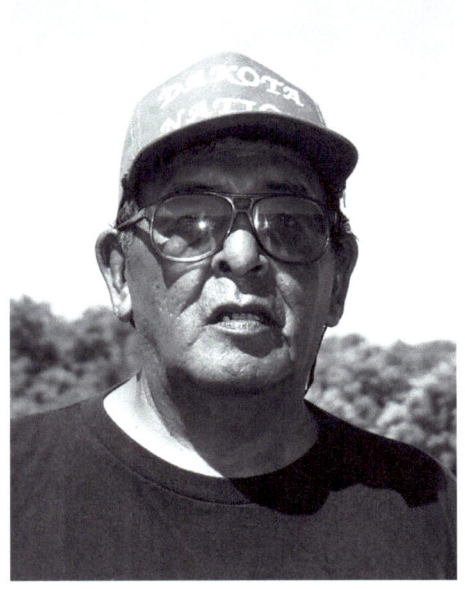

***Calvin* Medicine Bear First**

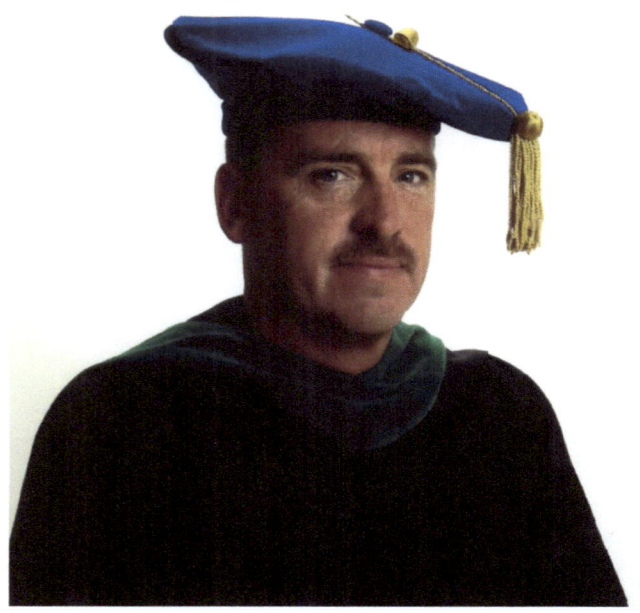

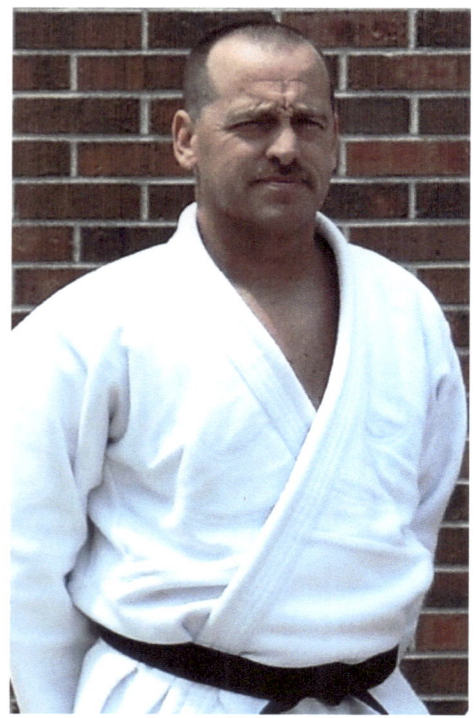

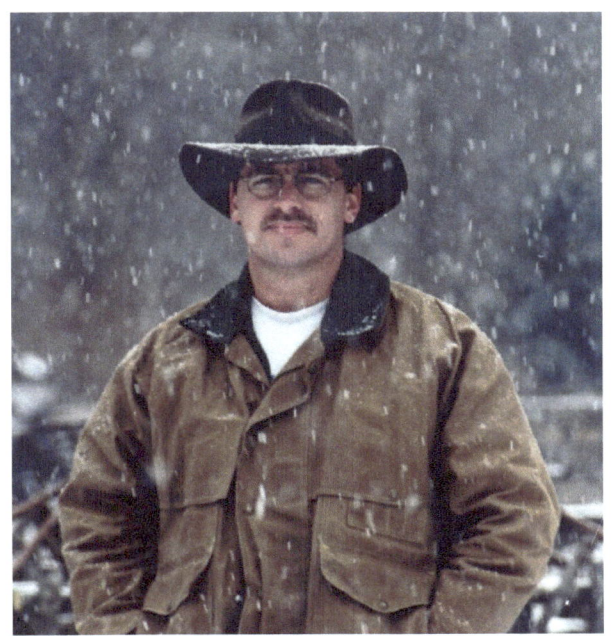

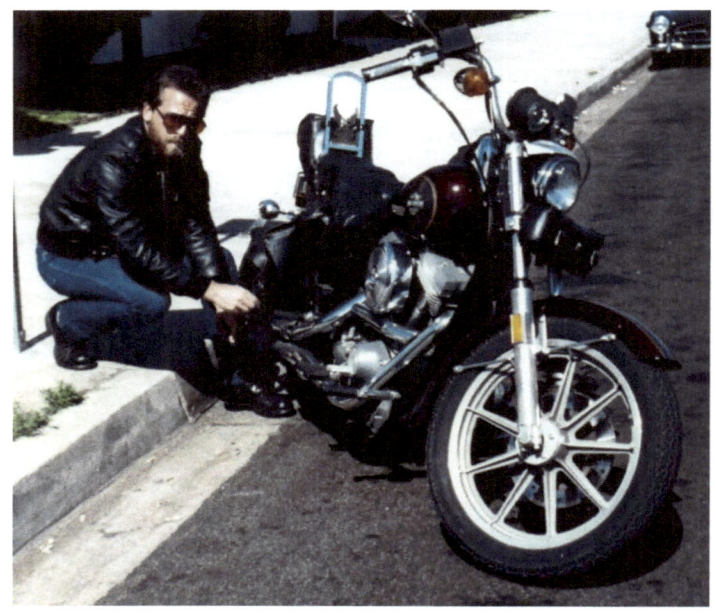

1985 FXRS Harley Davidson

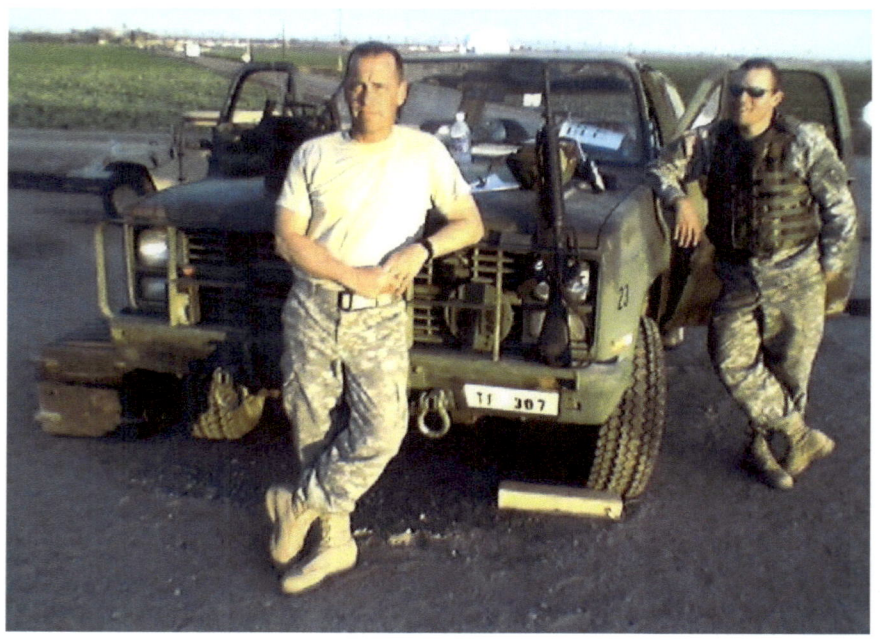

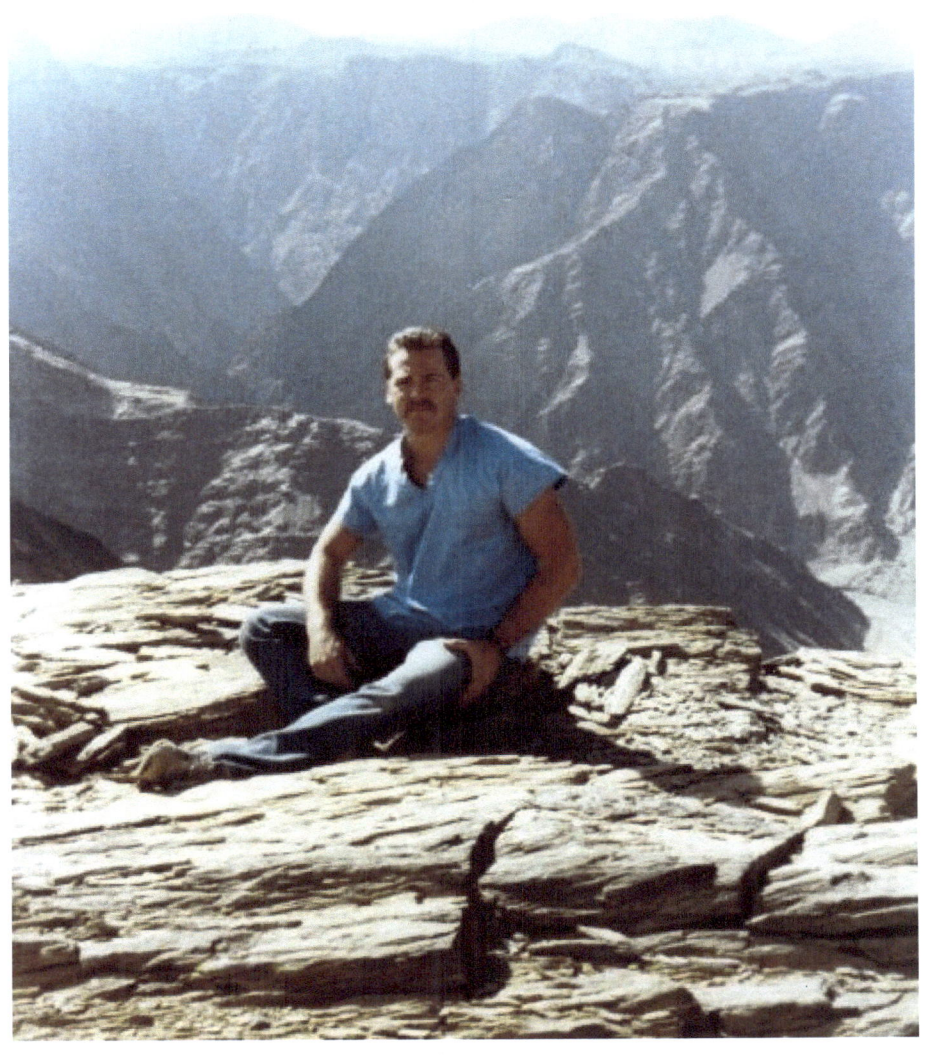

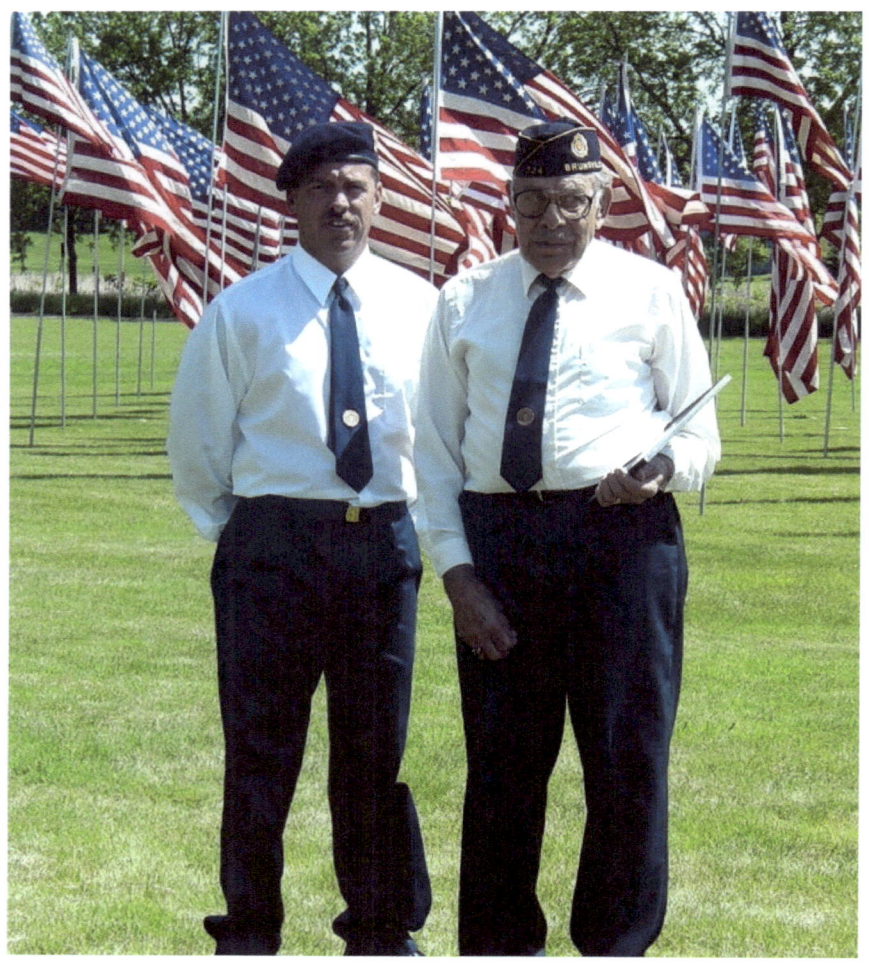

Memorial Day

The American Legion

Vietnam Veterans of America

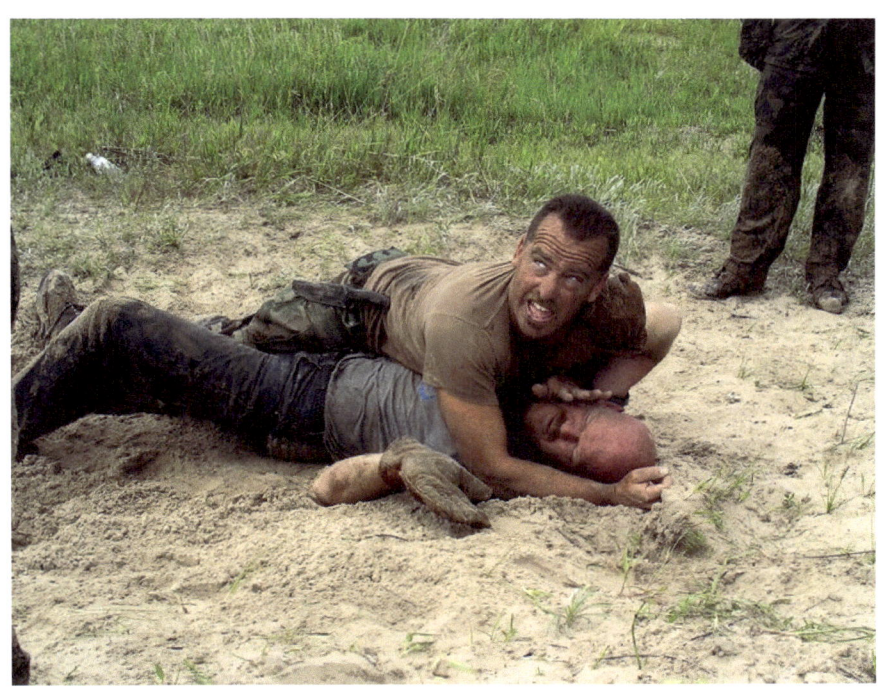

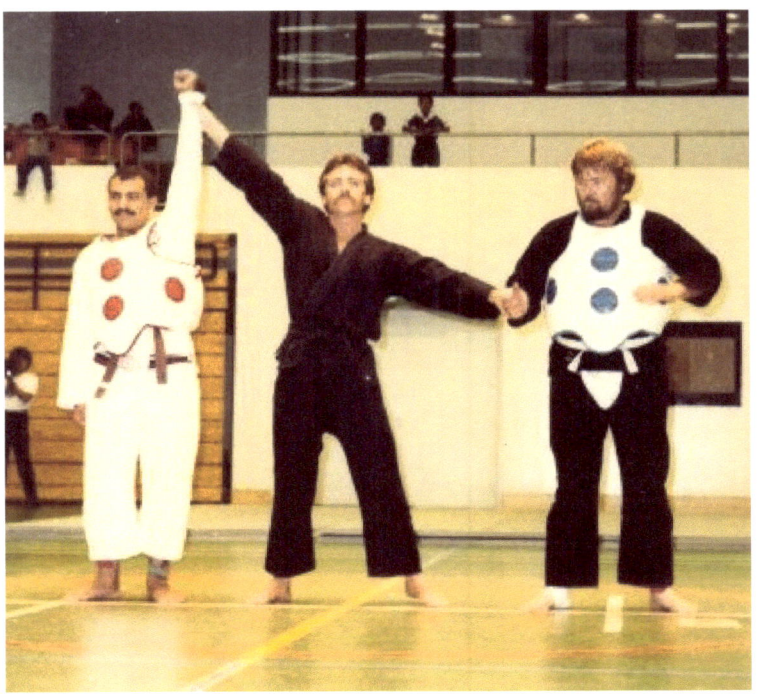

James Willer

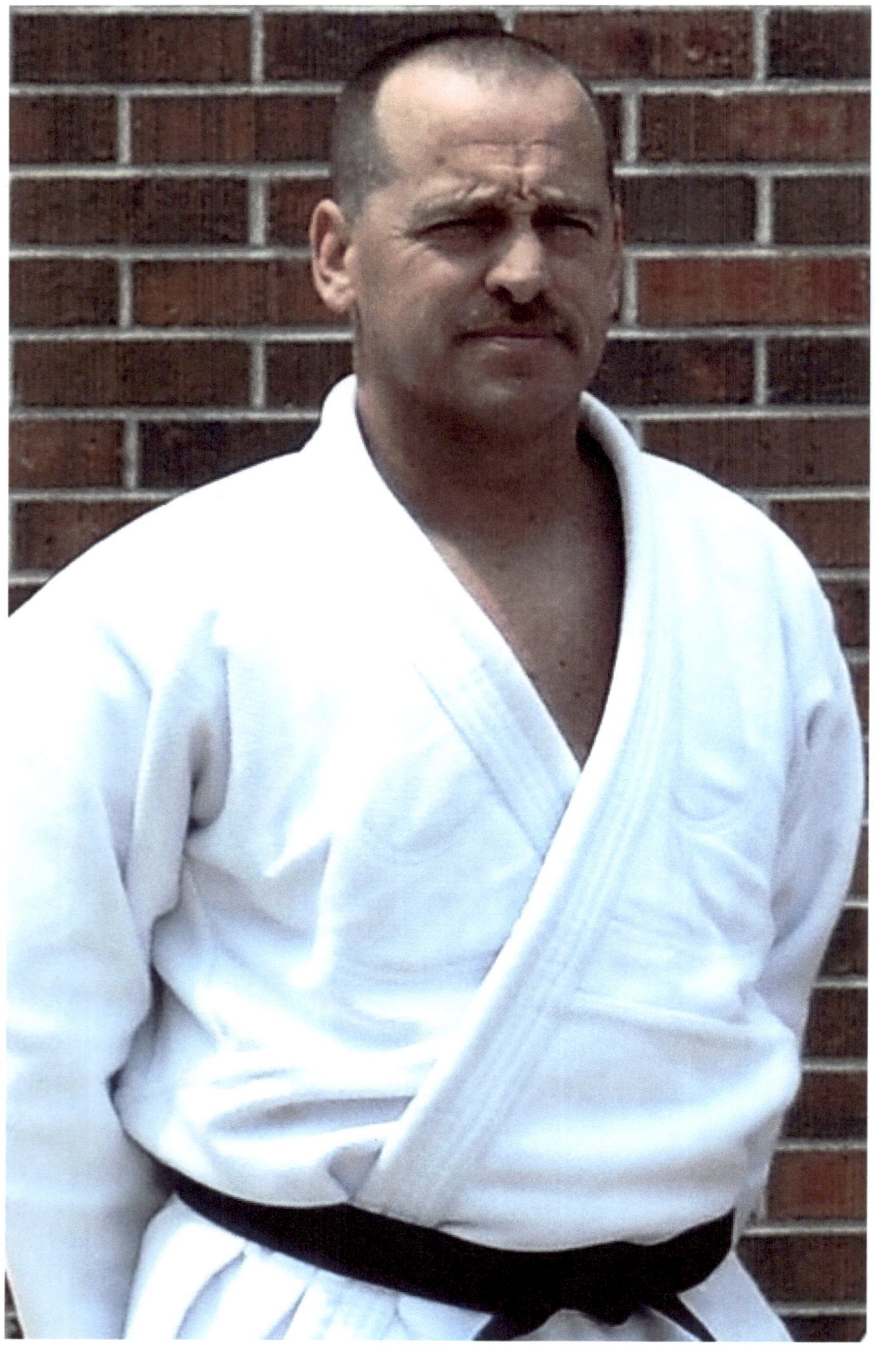

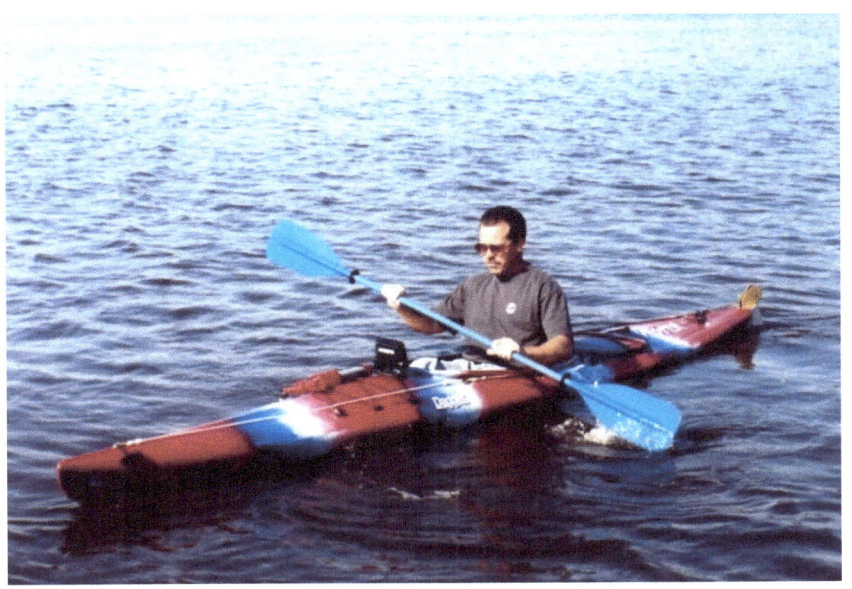

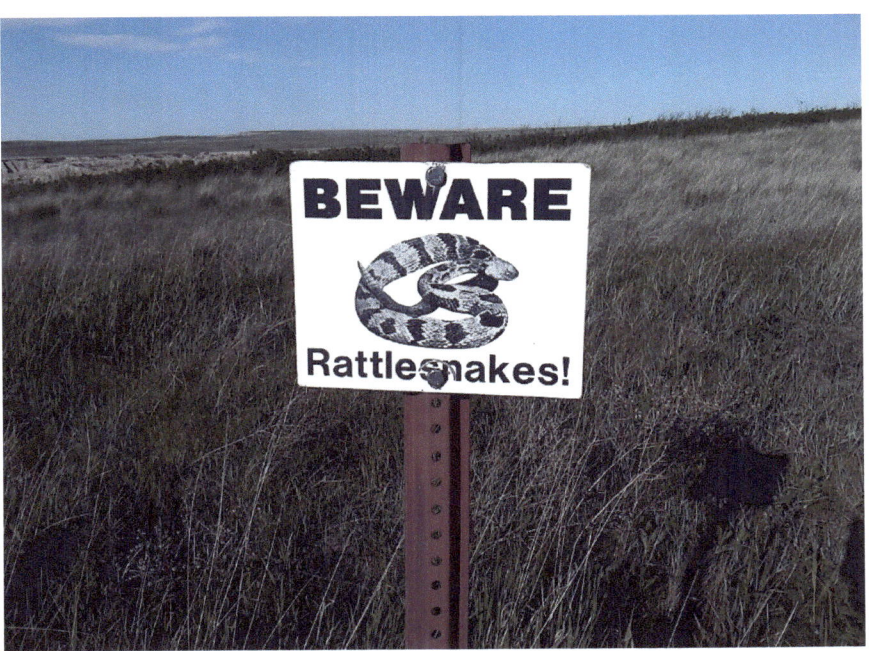

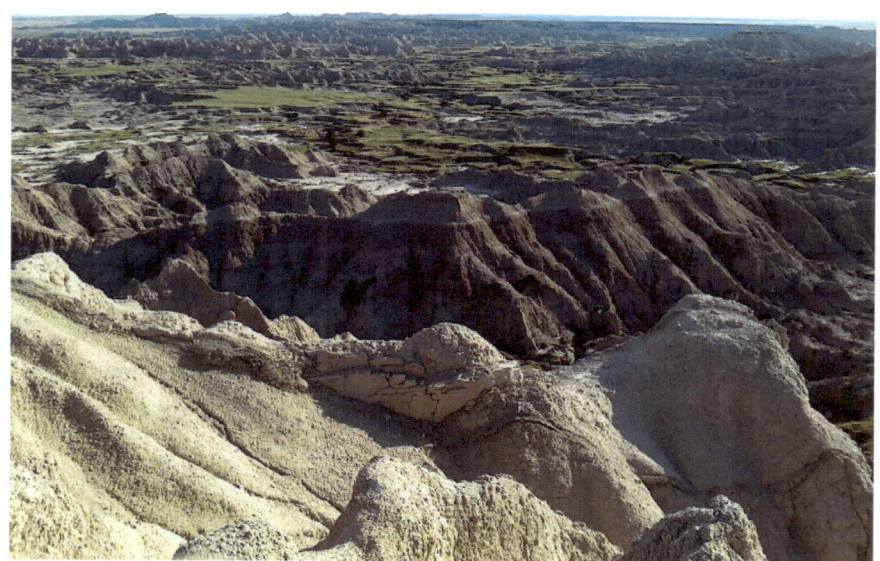

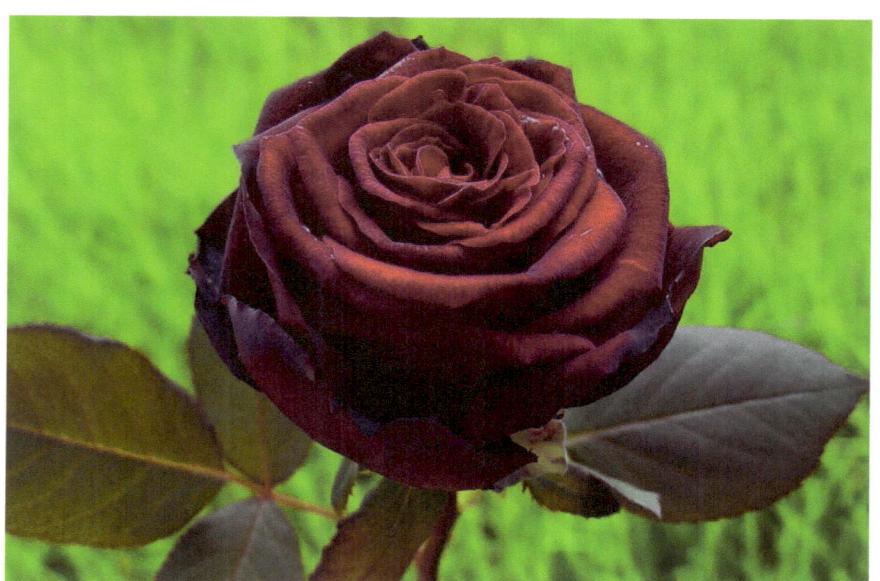

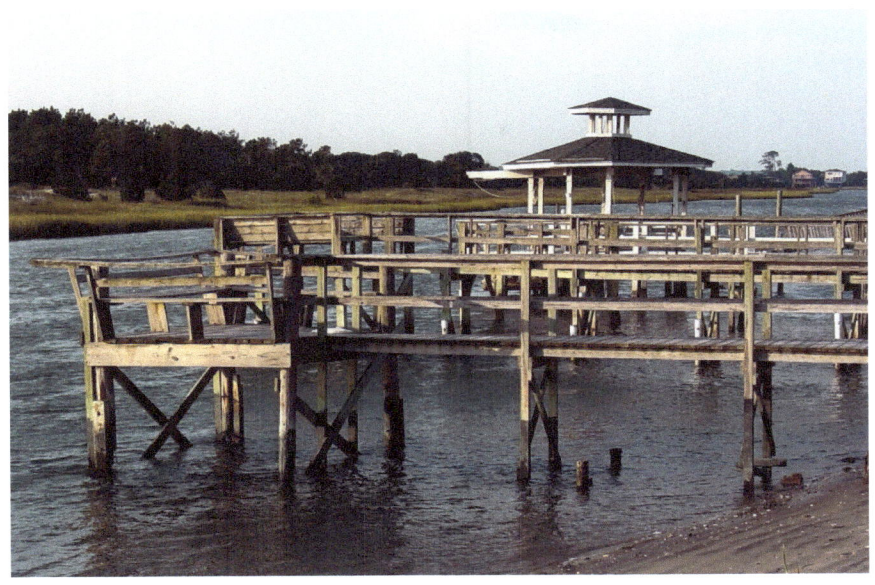

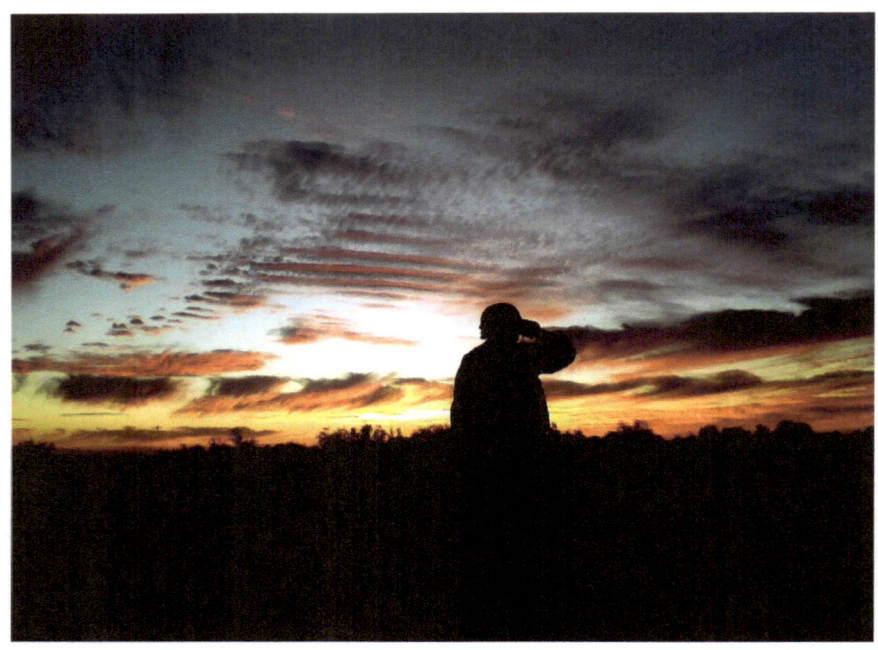

Some things in life can hurt you but most of the pain you suffer will not kill you.

ABOUT THE AUTHOR

Active as a Black Belt founder of American Martial Arts, served over a dozen honorable years of military police service to America, and completed a new military based novel, boredom is not part of his lexicon. With more than 20 years of diverse medical experience, Dr. Willer worked for ECPI University as a medical instructor. He holds a doctorate in Healthcare Administration from Warren National University, masters from Wayne State College in education, and is a certified cardiovascular technologist. He is currently working as a Private Investigator in North Carolina.

www.ingramcontent.com/pod-product-compliance
Lightning Source LLC
Chambersburg PA
CBHW041116180526
45172CB00001B/272